Line & Wash

Wendy Je

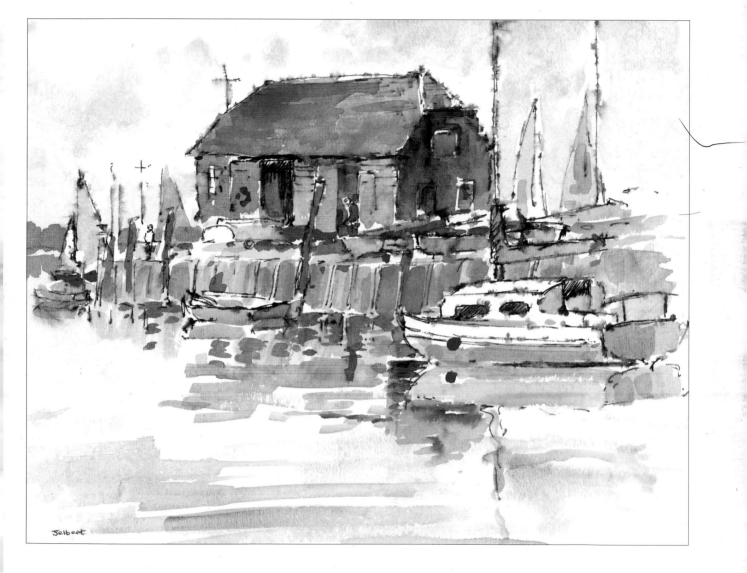

SEARCH PRESS

First published in Great Britain 1997

Search Press Limited
Wellwood, North Farm Road,
Tunbridge Wells, Kent TN2 3DR

Reprinted 2000, 2001

ISBN 0 85532 833 9

Suppliers
If you have any difficulty in obtaining any of the
materials and equipment mentioned in this book,
then please write for a current list of stockists,
including firms who operate a mail-order service,
to the Publishers:
Search Press Limited, Wellwood,
North Farm Road, Tunbridge Wells,
Kent TN2 3DR, England

Printed in Spain by Elkar S. Coop. 48180 Loiu (Bizkaia)

P<small>AGE</small> 1
Bosham harbour
*The pen and non-waterproof black ink outlines are
drawn in first, then paler watercolour washes are laid
into the background. Darker tones and stronger
colours are added to create depth, and ink shading is
worked into appropriate areas.*

Size: 360 x 275mm (14 x 10¾in)

B<small>ELOW</small>
Countryside tranquillity
*A pale blue wash over the distant hills breaks up the
soft brown washes of the landscape and sky. Brown
ink details and shading are drawn into the trees; the
foreground grasses are sketched in using both
watercolour and ink.*

Size: 305 x 145mm (12 x 5¾in)

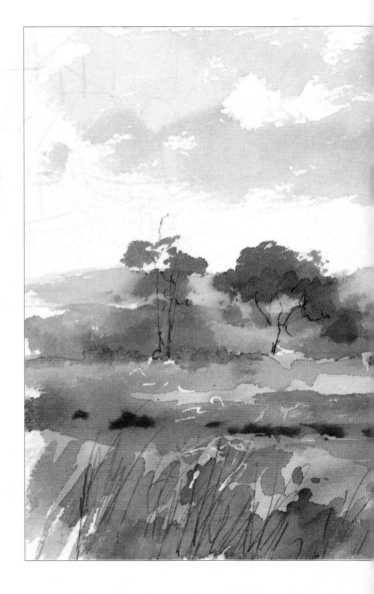

Contents

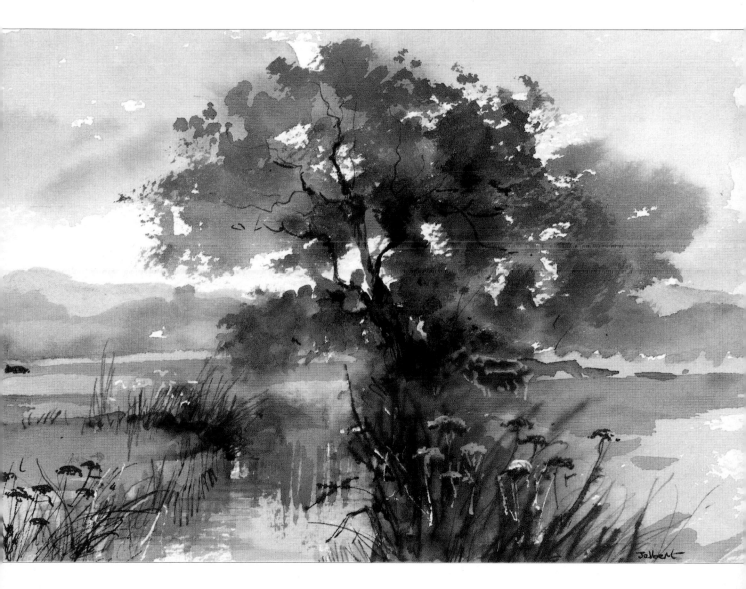

Introduction

One of the great joys of line and wash is the working and merging of different worlds – the sharp, crisp and definite markings of penwork, with the soft, loose and luminous effect of washes. You can choose a bold effect or a delicate pastel approach, a drawing or painting, in monumental or miniature scale – the wonderful flexibility of line and wash can accommodate many tastes and techniques.

When teaching, I find frequently that students have usually tried some form of painting during their lives, and everyone is familiar with using ink for writing. Drawing with ink, however, seems to be a neglected area. If students have experimented, they have often 'killed off' a picture with too many heavy black lines, or they have been deterred by the fact that ink cannot be rubbed out and mistakes cannot therefore be easily removed. However, misplaced lines really do not matter and in fact they can often add to a picture's spirit and vitality.

In this book I include many paintings, plus step-by-step demonstrations, to illustrate how to use watercolours, waterproof, non-waterproof and acrylic inks. Line and wash requires little equipment. It can be worked during any spare or snatched moment, on your lap or at a table. Great painters, such as Van Gogh and Rembrandt, found the technique a wonderful means of expression. Hopefully you will discover this also.

If you relax, practise the techniques and become familiar with the tools and colours, you will soon discover how the control of the pens and the freedom of the washes can complement each other to produce beautiful results.

The bridleway
The tree and gate are drawn in first, then watercolour washes are laid in to create the sky, foliage and grass. Foreground details are sketched in to complete the picture.
Size: 230 x 170mm (9 x 6½in)

OPPOSITE
Poppy time
Brown ink is used to tighten up the fence, tree and bright red poppies in this loose watercolour painting. Lines of ink help to define the landscape beneath the trees in the middle distance.
Size: 180 x 245mm (7 x 9½in)

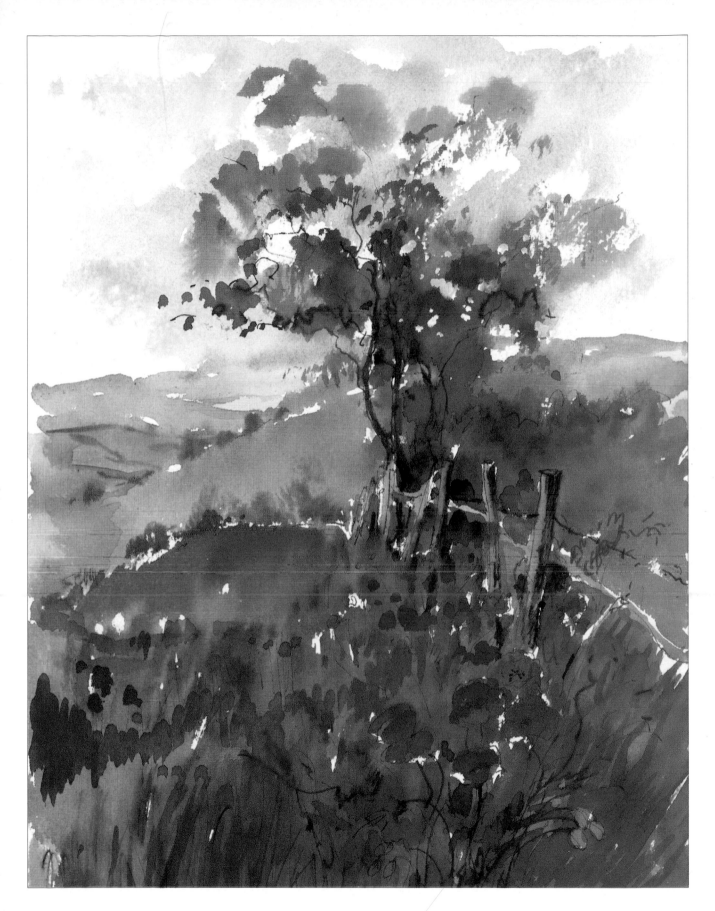

Materials and equipment

The materials and equipment required for pen, line and wash are basic and economical compared with other painting media. When venturing out on a sketching session, I often take just a pencil, rubber, ball-point pen and a small cartridge sketchbook.

Papers

You can use all sorts of paper, but the most common is cartridge paper – this is rather thin for washes, but it is excellent for dry sketches. For washy sketches, 190g (90lb) watercolour paper is ideal, but the heavier 300g (140lb) paper is best for most watercolour and pen work. Watercolour paper is available in three surface finishes: the hot pressed surface is smooth and good for detailed work; the not surface is slightly textured and is ideal for the beginner; the rough surface is very textured and I find it too much so for fine pen work.

Palette

Palettes are essential for mixing and grading inks. Ceramic palettes are available, but lightweight ones are good when working outside. I use an in-flight meal container, and I find the deep wide wells most suitable for my type of work.

Hair dryer

Not essential, but useful when you want to finish a painting in a hurry. Battery-operated dryers are ideal for the mobile painter.

Pencil and eraser

Two essentials for any artist, for making preliminary sketches in the field and for the initial, full-size drawing. Soft-leaded pencils make visible marks that do not leave indentations on the surface of the paper. Soft erasers, used with care, do not damage the surface texture of the paper.

Masking tape

Masking tape has a low tack which allows you to hold down the paper while you work, and then to remove it without marking the surface of the paper.

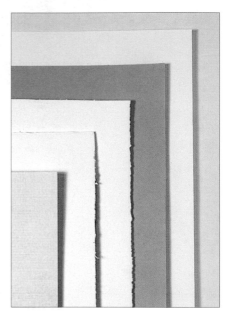

A selection of papers
From the front to the back: Cream not surface watercolour paper for coloured inks and monochrome studies; white 190g (90lb) watercolour paper – ideal for all work; white cartridge paper – ideal for sketching; blue pastel paper for white or coloured inks; white 300g (140lb) not surface watercolour paper – ideal for all work; and a textured paper, approximately 190g (90lb), for sketching or small wash studies.

OPPOSITE
Some of the equipment that I carry with me: a 24-pan palette of watercolours; a few extra colours in tubes, a battery-operated hair dryer; a mixing palette; a selection of inks; a soft pencil and eraser; and a roll of masking tape.

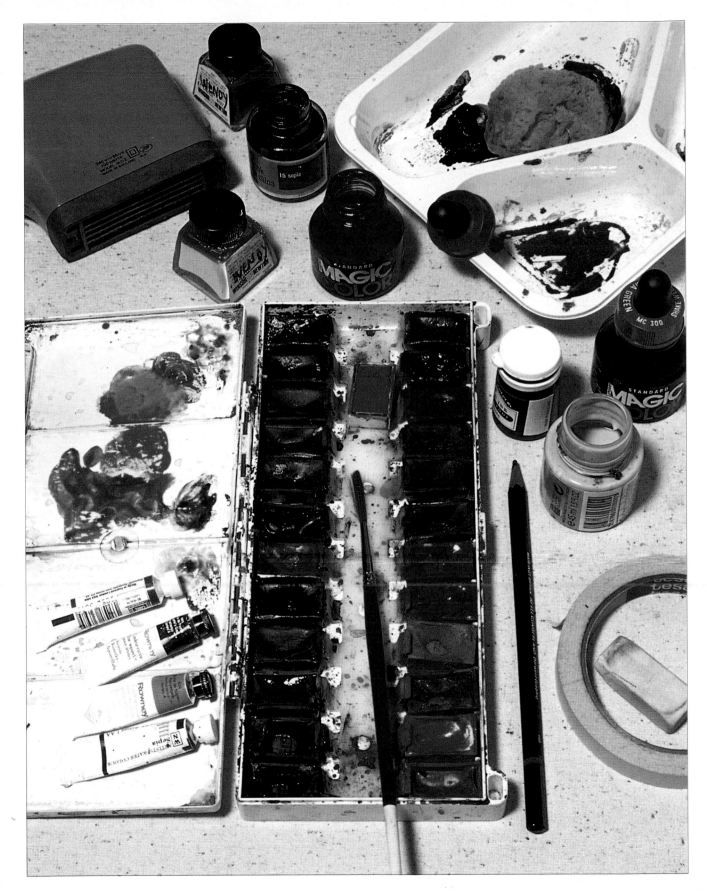

Inks

I use a variety of inks – waterproof, non-waterproof and acrylic.

Paints

Most makes of watercolour paints are ideal, either in pan or tube form. However, for outside work pans are more convenient.

Brushes and pens

There is a good variety of brushes and pens available to the artist. They all have their own characteristics and the choice is down to the individual. On these pages I show you some of the tools that I use and the type of image you can make with them. If possible, try out pens before buying them.

①

②

③

④

⑤

⑥

1. 20mm (¾in) flat-headed, ox-hair wash brush
2. No. 1 nylon rigger brush
3. Plastic pipette
4. Home-made bamboo pen
5. Traditional dipper pen with nib
6. Ruling or drawing pen
7. Ball-point pen
8. Waterproof ink brush pen
9. Waterproof ink, steel-nibbed technical pen
10. Non-waterproof ink, fine point, felt-tip pen
11. Waterproof ink, medium italic felt-tip (calligraphy) pen
12. Non-waterproof ink, sketching art pen

Playing with inks

Waterproof and non-waterproof inks are available in a range of colours, and there are many subtle differences between them. As you work, you will gradually discover how much water to mix with each, how much pen work to use to achieve a particular tone, how to control the flow of ink when used neat or when mixed with water . . . it is all an adventure.

A successful line and wash picture is not just about observing the lines around objects, but about interpreting the spaces within by using a series of textural marks. The magic of a surface will appear through observation and study. Often, the outline is very understated, or fragmented, if it is there at all.

Begin by collecting several objects such as a slither of wood, a sponge or a shell. Try to imitate the individual surface markings by producing some form of texture using either cross-hatching, dots, stabbing marks or broken massed lines (see page 12). Remember, the closer the marks are, the darker the tonal effect will be.

Venture out into the garden or look in your vegetable tray or sewing box. How do you define what you see? What makes a brick wall a brick wall? How does a corn-on-the-cob differ from a garden path, foliage or a reel of thread?

River Stour, near Flatford Mill
Waterproof and non-waterproof inks are used to sketch in the details; water is washed into the inks, and soft brown ink washes are worked into the foliage and foreground area.

Size: 280 x 190mm (11 x 7½in)

10

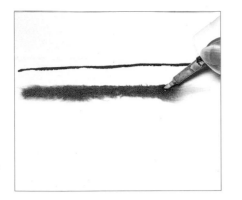

Practise working with line and wash. Draw a straight line at the top of the paper using waterproof ink. Now wet the paper and apply a line beneath.

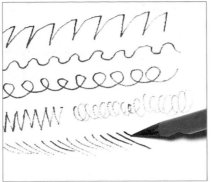

Use a bamboo pen and waterproof ink and practise making different marks.

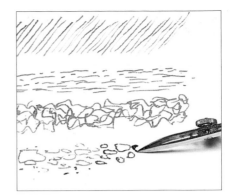

Draw different lines and shapes using a ruling or drawing pen and non-waterproof ink.

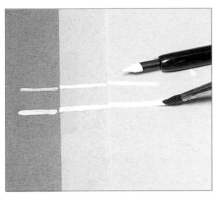

Use white acrylic ink on different coloured papers.

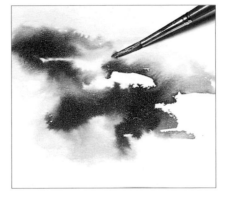

Drop non-waterproof ink on to a wet surface. Notice how the colours spread and separate.

Use white acrylic ink on a dark background using a steel-nibbed pen.

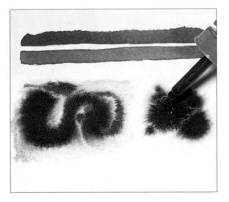

1. Apply a two-colour glaze using acrylic inks at the top of the paper. Wet the paper beneath and drop the paints on to the surface.

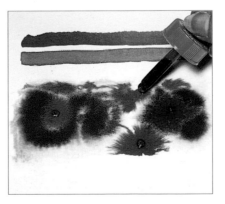

2. Add a new dimension to the washes by dropping in green.

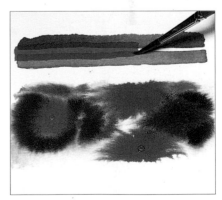

3. Apply green between the two glazes.

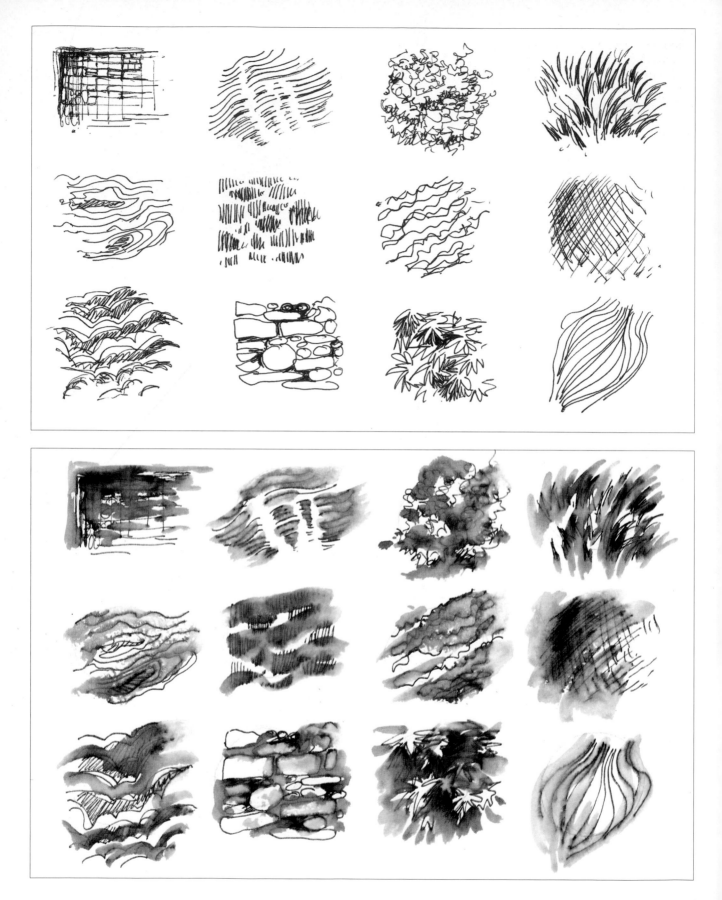

LEFT
Choose a selection of objects to sketch. Using a simple dipper pen and waterproof ink, doodle and scribble what you see on to cartridge paper, or keep a record of your practice sketches in a sketchbook. Study the surface and form of each object and capture the essences of each. This simple exercise will help to improve your powers of observation and drawing skills.

Sepia acrylic ink applied with a dipper pen and washed over before it dries

Clean water washed into non-waterproof ink to produce a diffused effect

Steel-nibbed pen

Brush pen

LEFT
When you have completed your doodles, practise creating different tones. Repeat the sketches, but this time use a non-waterproof ink. Using a brush, gently wash clean water over the surface of each pen study.

Disposable steel-nibbed waterproof pen used to achieve fine detail

Waterproof brush pen applied with different pressure to create varying line widths

Non-waterproof art pen washed over with clean water and a soft brush

Autumn arrangement

For this exercise I use a combination of waterproof and non-waterproof inks to depict the rich textures of cow parsley, dried sorrel and grasses. When collecting these plants together, I was fascinated by the lovely harmony of colours and the subtle tonal contrasts.

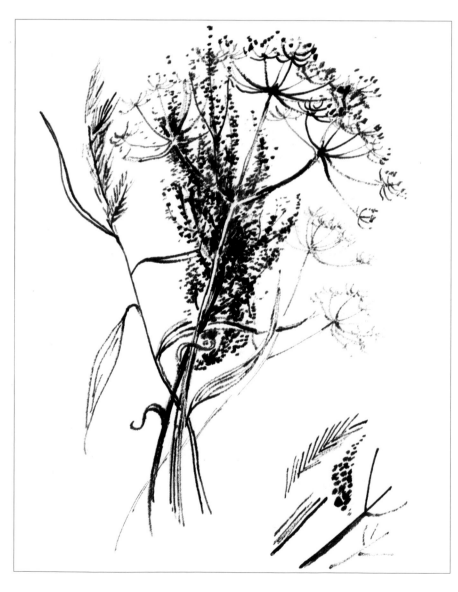

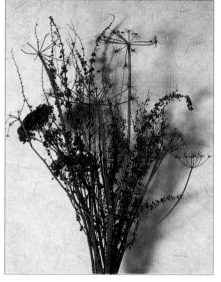

1. Make an informal arrangement of the dried flowers and grasses; study them carefully, then make a preliminary sketch. Practise drawing the leaves and flower heads – this will help you work out the tones and textures needed for the finished painting.

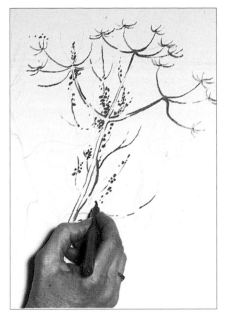

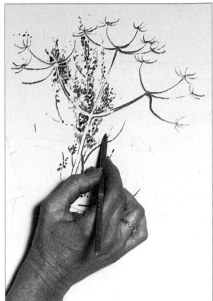

2. Use a soft pencil to draw in the outlines of the dried flowers, taking care to leave darks against lights.

3. Start to build up the picture, brushing in the darks against the lights using a brush pen.

4. Use a bamboo pen and waterproof ink to add a mixture of brown and deep red to the background to highlight the stems.

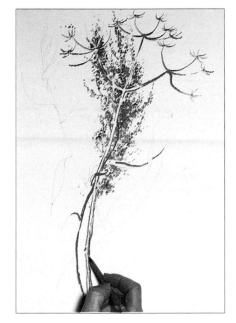

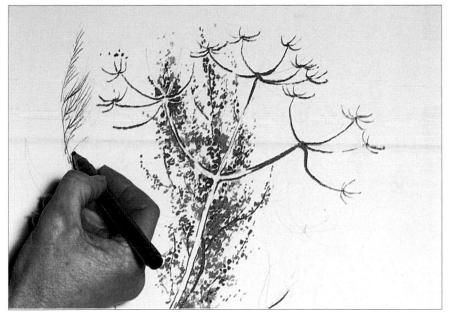

5. Add colour to the stem of the main plant using the bamboo pen.

6. Draw in thick and thin variations of line with an italic calligraphy pen. Use the pen to full advantage by carefully outlining the grass head in non-waterproof ink.

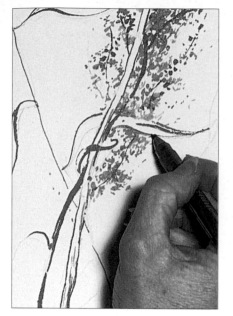

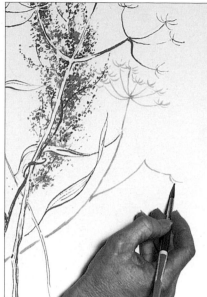

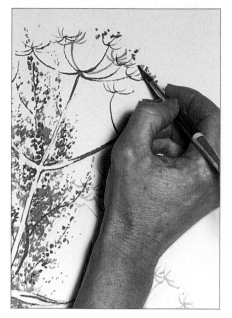

7. Carefully draw in the leaves with the calligraphy pen.

8. Apply a lighter brown to the background flower using a brush; this will give a softer outline than a pen and it will also accentuate the perspective and give a feeling of distance.

9. Add more flowers to the background behind the main flower.

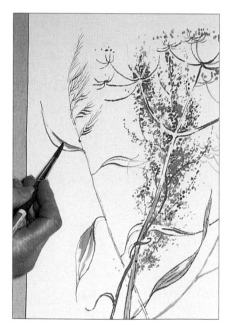

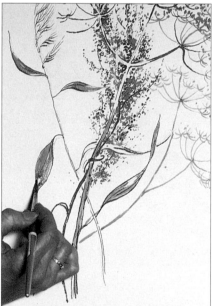

10. Add touches of brown to the leaves to give form and texture.

11. Finally, brush yellow ink into the leaves and the grass head.

Opposite
Autumn arrangement
The finished picture.
Size: 255 x 380mm (10 x 15in)

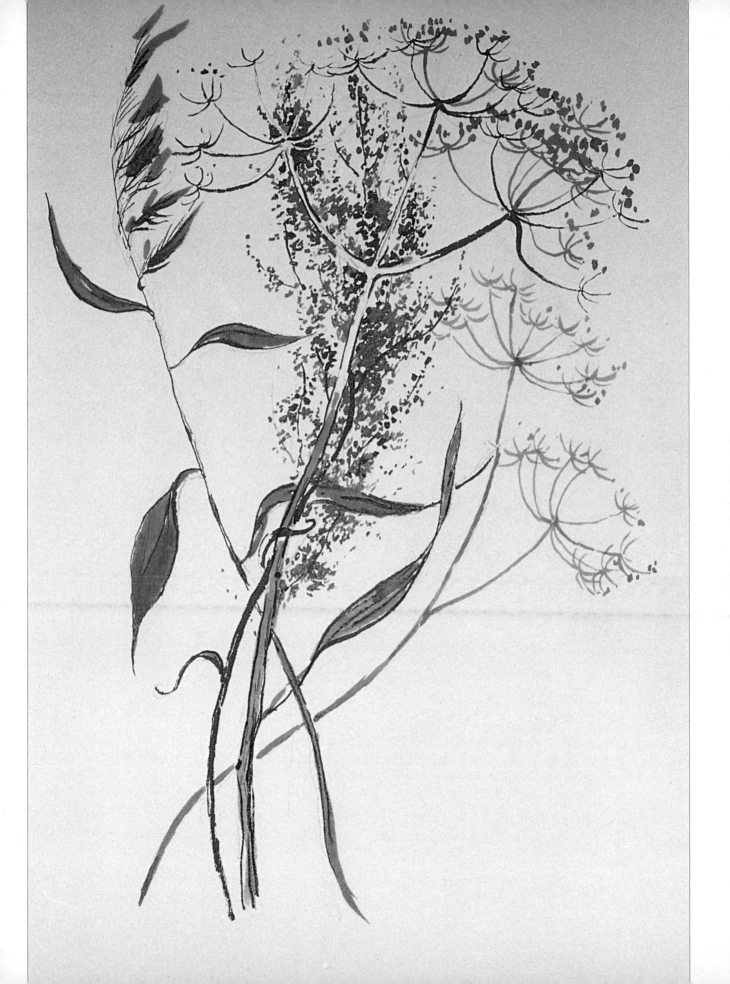

Playing with paints

When you are painting a naturalistic subject, achieving the required tone is vital and this can only be done if you understand how colours react with water. The more water you add, the thinner the wash becomes and the lighter the tone achieved. Tone is also affected by the luminosity of the paper and the colours on to which the washes are applied. Delicacy and subtlety, especially in light areas, are the secret of successful watercolour washes.

A wash can comprise one smooth tone, or the colour may be gradated into various tones.

Building up layers of washes will transform the colours both on top and underneath.

To begin with, practice making washes with just three colours such as blue, red and yellow. Try to gradate each colour through from the darkest tone to the palest pastel wash. You will discover that each colour requires a different amount of water to obtain a certain tone.

Study the four washes below and then practice and experiment until you become familiar with the effects that can be created.

 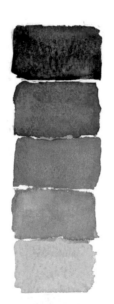 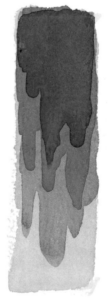 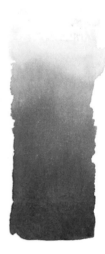

Wet-into-wet
To achieve this fluid effect, apply a wash of assorted tones then drop colour in to merge with the background. This wash is spontaneous and full of vitality . . . and surprises!

Adjacent wash
Apply five adjacent washes, beginning with a neat, dark, flat wash then gradating into paler washes. The washes should be close together, but they should not run or seep into each other.

Overlaid wash
Apply a light uniform tone with a wide brush, then leave to dry. Using the same tone, apply a second wash, partially covering the first one. Leave to dry and then repeat the process. Notice how much deeper and darker the tones become with each application of wash.

Graded wash
Apply a dark, almost neat wash using a brush at least 20mm (³/₄in) wide. Working quickly, add a little water and apply another layer of wash. Continue, ensuring that each new wash is progressively more watery than the last.

Strawberries

This is a simple exercise designed to help you understand the complexity of the different washes.

You will need
No. 6 or 8 paintbrush
Masking fluid
190g (90lb) watercolour paper
Watercolour paints: alizarin crimson, yellow ochre, mid-green and blue
Sepia waterproof felt-tip pen

1. Begin by arranging your fruit and then draw it in using the sepia waterproof pen.

2. Dot in the textured pip markings using masking fluid on the brush handle. Leave to dry.

3. Block in two strawberries using a combined wash of watery and neat crimson (*adjacent wash*).

4. Drop in a little yellow ochre into the front strawberry while the crimson paint is still wet (*overlaid wash and graded wash*).

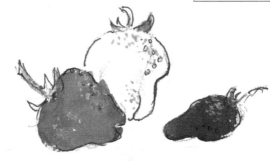

5. Next, wash yellow ochre all over the background (*graded wash*).

6. Paint in the last fruit (*graded wash*). Deepen the shadow on the small strawberry on the right using the same colour (*overlaid wash*).

7. Mix yellow ochre with green; dot this on to the small leaves. Add a layer of crimson to the left hand side of each strawberry to give a little more structure to the fruit (*overlaid wash*).

8. Rub off the masking fluid; wash in pale crimson to blend in the texturing. Repaint and darken the background using more ochre (*wet-into-wet wash*).

9. Paint in the shadows using a blue wash with a touch of crimson (*adjacent wash*). Draw in details of the strawberries with a felt-tip pen.

Mushrooms

Line and wash is such a diverse technique, that it is often difficult to know exactly what effects are possible. This mushroom project has been devised to clarify what is covered by line and wash, and the various methods are shown and described below. Each exercise needs to be lightly sketched in before you start.

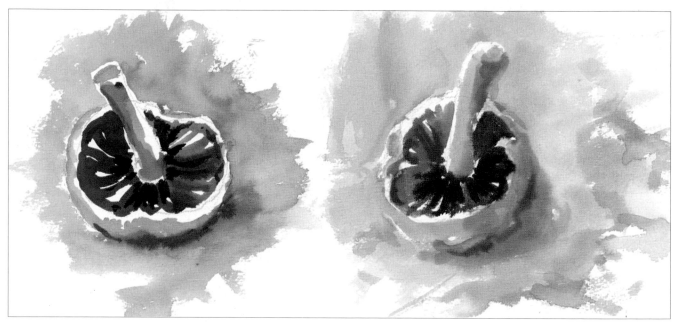

Monochrome
Study the tones in the mushroom. Notice where the lightest and darkest points are. What is happening in the background? Is it darker or lighter than the mushroom? Use a brush to mark in the darkest and lightest tones with either sepia ink or watercolours. Here, the dark tones of the gills contrast with the lighter tones of the top of the mushroom and the stalk. Add in the mid-tones in the background to accentuate the shape of the mushroom.

Waterproof ink that separates in water
Most black inks separate when mixed with water to form several colours. You can either mix the ink with water in your palette, or you can apply the ink to the drawing and then drop water on top. Combine this technique with monochrome, and use neat and diluted washes of ink to build up the mushroom.

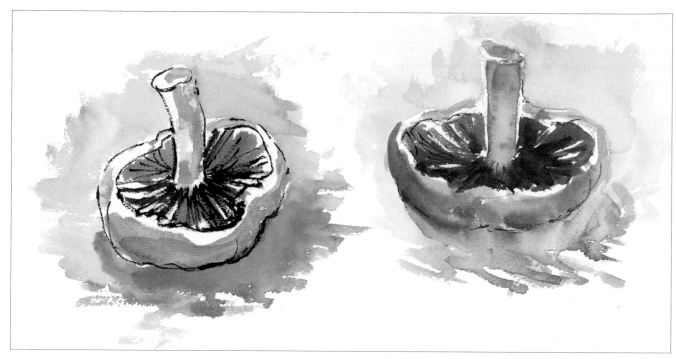

Brush pen

Outline the mushroom with a black, bold waterproof brush pen, varying the pressure to change the strength of the line. Paint in the mushroom using blue and brown watercolours.

Watercolour washes

Use watercolours to flow over the form of the mushroom, and then highlight small details with tiny trails of ink work.

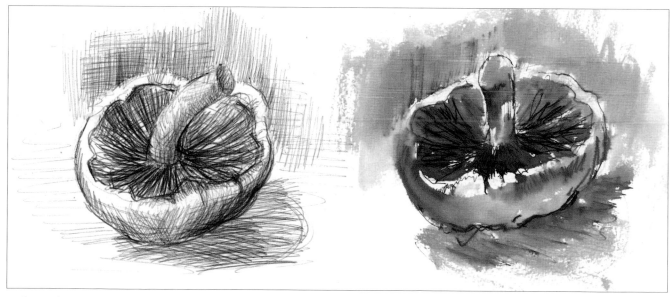

Ink work

Cross-hatch the whole surface, or draw a series of lines to follow the structure and contours of the mushroom. Use any pen for this exercise – even the common ball-point pen works well.

Non-waterproof ink

Non-waterproof inks are very adaptable and can be used with and without watercolour and water washes. For this exercise, use non-waterproof ink with a pen and water. When dry, work into the surface with a pen.

Landscapes

Trees

Trees are an important feature of the landscape. They can take different shapes, sizes and colours and they can add variety, texture and mood to a picture. Whether you choose to paint a single tree or a group of trees, you will have to resolve the problem of how to illustrate foliage. The secret is to keep it simple, resist the temptation to over-paint, and leave lots to the imagination. To achieve a basic shape and character, always look for the negative shapes amongst the foliage (the areas of sky in between the branches).

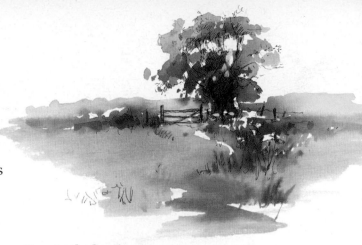

Tree in the landscape
This tree settles naturally into the scene. It is given size and proportion by the inclusion of a path and gate. It is built up with watercolour washes, and pen work is used to emphasise the bulk of the tree and the gate.

Size: 190 x 110mm (7½ x 4¼in)

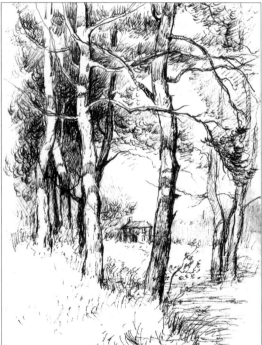

Winter trees
Here, the skeletal splendour of the trees is displayed. The textural and tonal contrasts have been exploited to the full with finely detailed pen work.

Size: 125 x 175mm (5 x 6¾in)

Parts of a tree
Specific parts of a tree, such as roots, broken branches or fallen twigs, can act as a fascinating focal point. In this study, remains of trunks are dramatically painted in a non-waterproof ink, with the flow of ink giving character and form to the writhing roots.

Size: 280 x 125mm (11 x 5in)

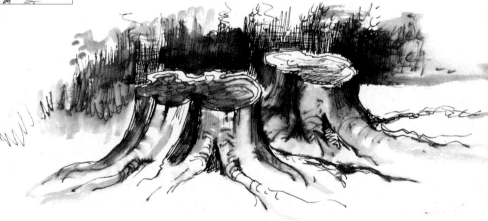

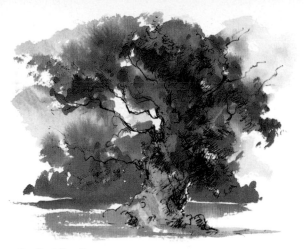

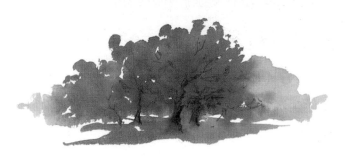

Individual trees

A tree has to be powerful to be able to stand alone successfully. Here, the strong drawing network in pen helps to give it strength. For the sky and the leaves, a wet-into-wet series of watercolour washes are applied over the initial drawing.

Size: 150 x 125mm (6 x 5in)

Groups of trees

Linking several trees to form an attractive feature is essential for landscape work. Variety in colour and texture is important. Here, a non-waterproof ink is used, and the greens are run over the drawing to join the trees loosely.

Size: 165 x 75mm (6½ x 3in)

Autumn birches

These birches are sketched in with a sepia waterproof pen. The light shapes are achieved with masking fluid and they highlight the wonderful contrasts of the delicate trees. Finally, the tiny speckled leaves are dotted on using a fine sponge dipped in sepia ink.

Size: 245 x 160mm (9½ x 6¼in)

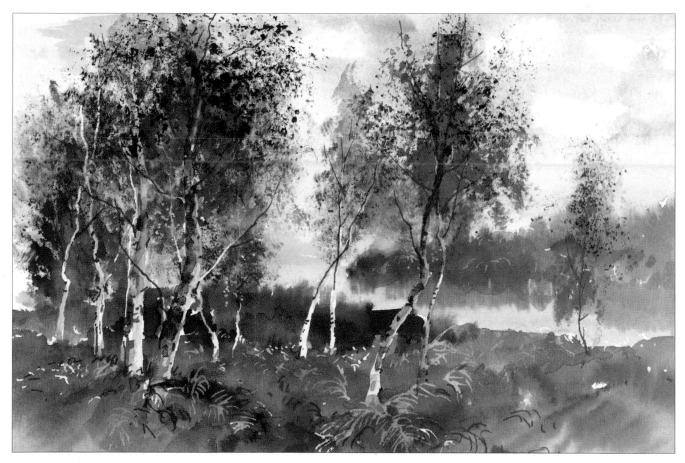

Allotments in the snow

I was so attracted to these decaying buildings and the subdued colours of the scene in general, that I took a photograph for reference. On a later visit, snow had fallen and the web of snow-laden branches on the large old tree fragmented the whole scene. I then made the sketch below which is used for this exercise.

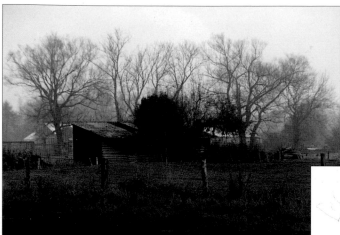

The original photograph and sketch of the scene.

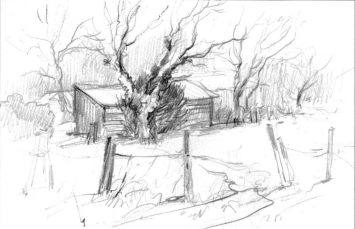

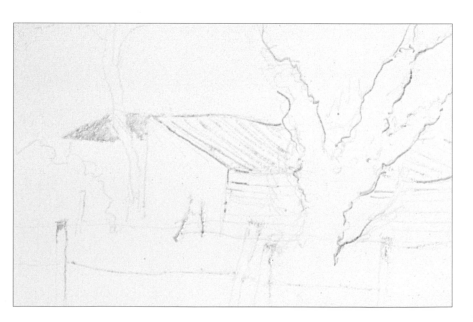

1. Sketch in the picture, beginning with the outline of the tree.

2. Mix a little blue with the masking fluid and, using a ruling or drawing pen, apply it to the tree, buildings and tops of the fence posts.

24

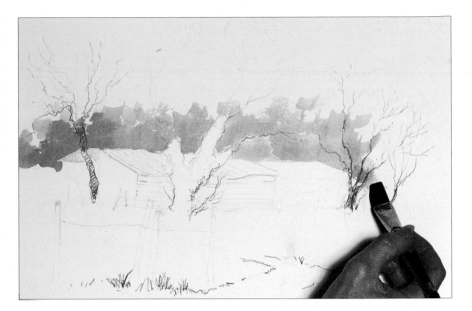

3. Draw in the trees and fore-ground grasses using waterproof sepia ink and a pen.

4. Lay in a wash over the hazy background area using a flat-headed brush and diluted blue non-waterproof ink.

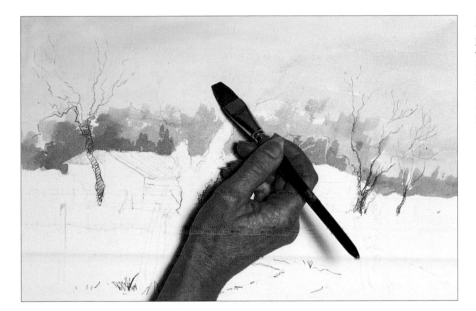

5. Darken areas of the back-ground, then blend Naples yellow over the sky from right to left, diluting the colour over the buildings. Blend in violet from left to right, taking the wash over the trees.

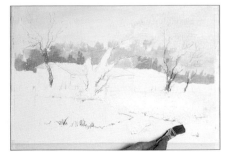

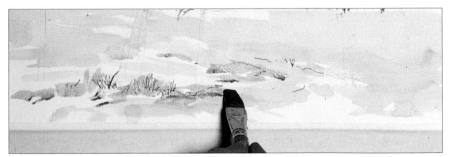

6. Blend Naples yellow and violet over the foreground, echoing the colours of the sky.

7. Lay in a blue watercolour wash to add interest to the foreground.

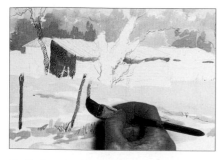

8. Paint in the buildings and fences using a mix of burnt sienna and violet.

9. Add a mix of cerulean blue and violet to the front of the buildings.

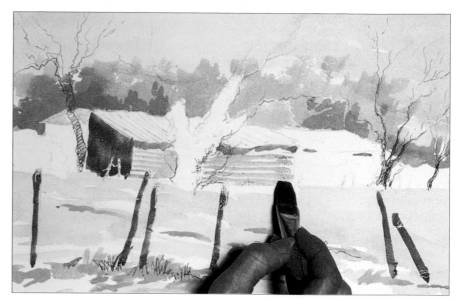

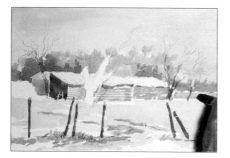

10. Add cerulean blue to the middle distance on the left and to the back building, to create shadows and darker areas.

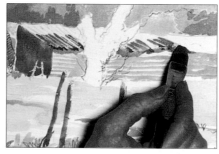

11. Mix orange and burnt sienna and paint in the rusty roof, adding a blue wash for the shadowed areas.

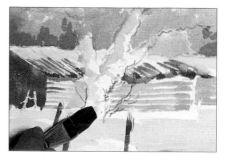

12. Paint the snowy areas on the main tree using a pale blue.

13. Add more shadows and texture on the tree trunk with non-waterproof ink. Add finer details to the trunk and branches with the art pen.

14. Soften the ink by adding water and washing the colour over the tree.

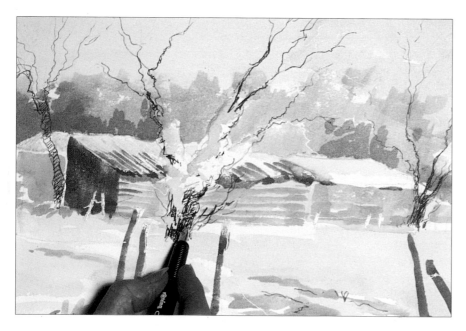

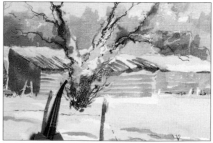

26

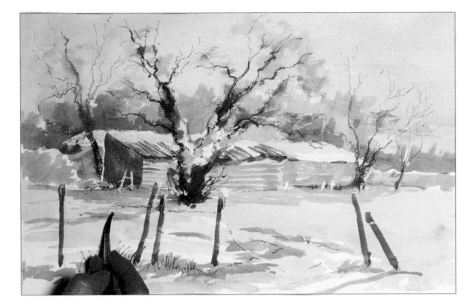

15. Add blue shadows to all areas of the landscape to give depth and perspective.

16. Finally, rub off the masking fluid to reveal highlights and areas of snow.

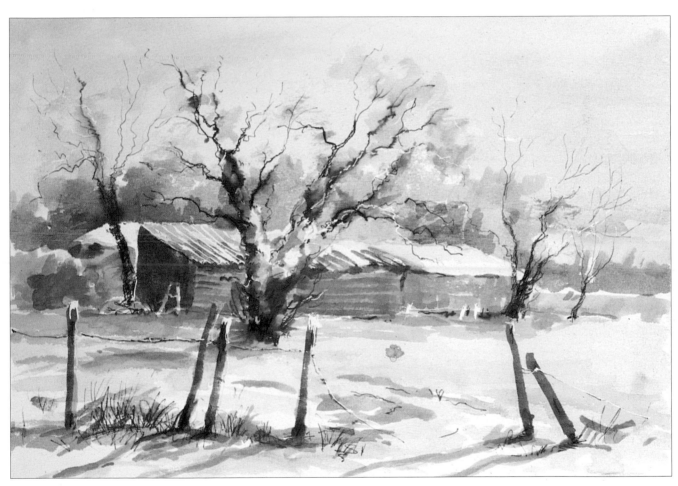

Allotments in the snow, *the finished painting.*
Size: 360 x 255mm (14 x 10in)

Three styles of landscape

A landscape harbours the seasons, weather changes, and juxtapositions of shape, colour and tone. Initially, you may find this subject daunting, but there are simple approaches to landscape painting, and pen and wash are superb vehicles for any study or piece of work. Here, I have painted the same scene using different techniques to achieve varied effects.

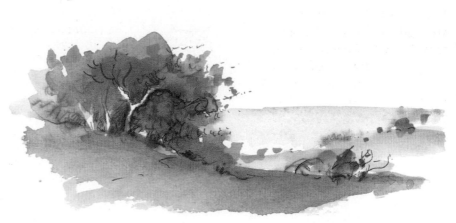

This study begins with a quick, fairly rough drawing using non-waterproof ink. Washes of different greens are applied to the trees and fields, varying the colours slightly. When dry, more pen work is applied to accentuate tree details and the simple foreground.

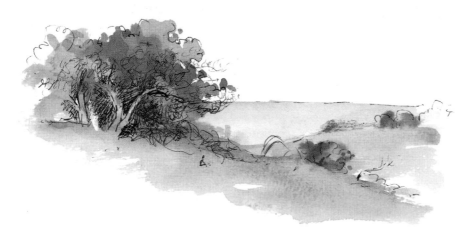

An outline sketch is drawn in using a waterproof black pen, with cross-hatching for the dark shadows of the trees and surrounding shrubs. Care has to be taken not to make the lines too strongly defined in the distance. Textured pen work creates the deeper tone, so watercolour washes are kept simple.

A mixture of waterproof and non-waterproof black inks are used here. Wet-into-wet colour washes are painted in and some of the ink runs into the colours to create a smoky effect.

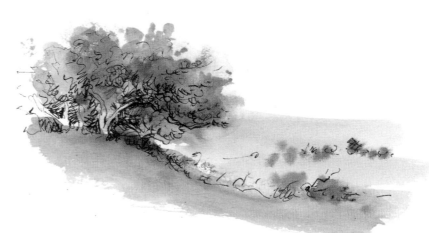

Monochrome studies

You should be aware of the strengths of your inks, and be familiar with how to use them – either boldly or softly.

Divide your palette into four sections and add black waterproof ink to each. Dilute three of the inks with different amounts of water and leave the fourth neat.

Try out one type of ink and make a gradated tone. Apply a band of neat ink and slowly add water to it to produce a trail of ink, gradating in tone from dark to light, as illustrated.

Drop the black ink into a wetted surface and tilt it from side to side allowing it to merge and flow together to produce different tones and patterns.

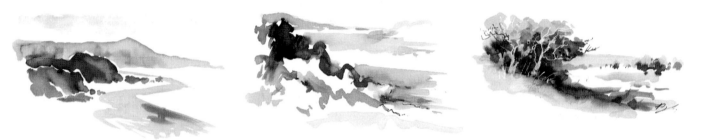

These three monochrome samples are taken from my sketchbook. They illustrate how important the 'jigsaw' build-up to a landscape is – how the dark and light, large and small, angular and round shapes fit together.

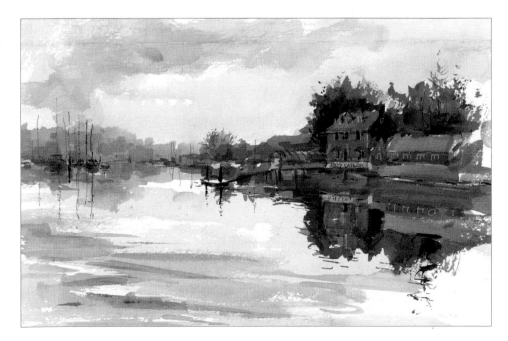

The Jolly Sailor
Reflections often appear complicated, but by painting the exact mirror image in 'wiggles', you can quickly and easily create the illusion of moving water. This monochrome uses sepia watercolours, but it could have been worked equally successfully in ink. The dense tones and sepia pen work are worked around the main feature, the public house.

Size: 335 x 190mm (13 x 7½in)

Tranquil river
This landscape is painted using coloured inks – orange, yellow, blue and green mixtures – and details are added with a sepia felt-tip pen. A little masking fluid is used to highlight the sunlight on the branches, the water and the backs of the cows. When dry, more details are drawn in using the same ink. Scribbles on the surface of the water suggest movement, and leaf textures are drawn in on the central tree.

Size: 200 x 260mm (8 x 10¼in)

ABOVE AND RIGHT
Country walk
Here are two paintings of the same scene. The one above is a simple sepia monochrome; the other is painted using light washes of pale green with cerulean blue and raw umber. An art pen is used for the drawing and it is allowed to seep into the wet-into-wet watercolour washes.

Size: 200 x 255mm (8 x 10in)

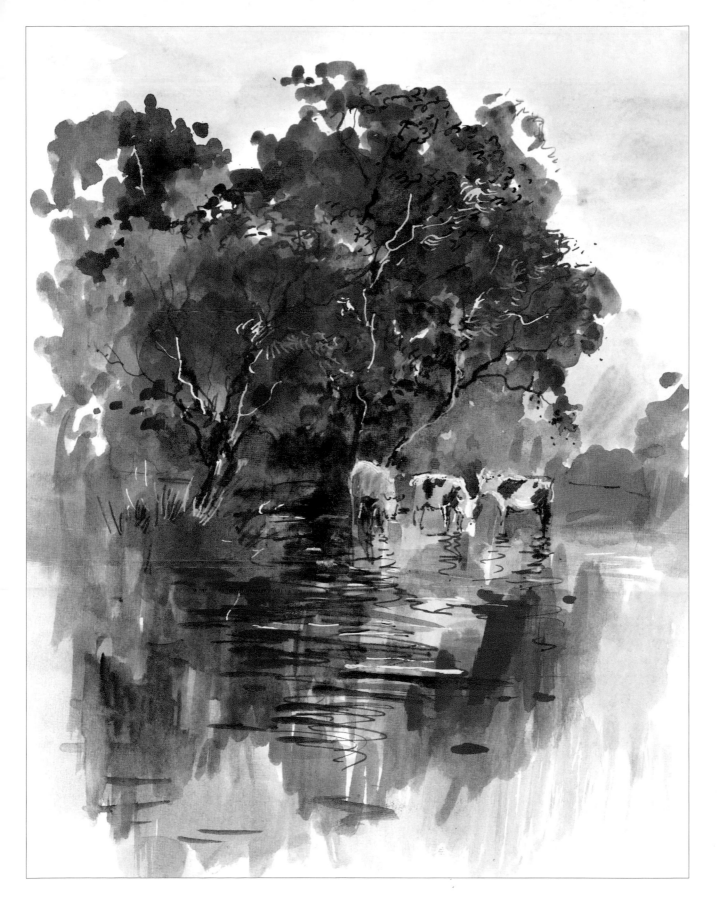

Flowers

One of the benefits of choosing flowers as subjects is that they are easily obtainable all year round – from garden centres, gardens and florists. When painting flowers, a basic knowledge of their structure helps, but the most important thing is observation. To paint or draw an 'impression' of something is never just an accident – it is achieved through a deep understanding of the subject.

Study how many leaves or petals a flower or plant has and examine how they are attached to the stem – you may find it helpful to look at some of the many excellent nature books that are available. Constant observation trains the eye and hand, so take any opportunity to study the subject and practise producing quick sketches – you can use a sharpened matchstick with the inks, or a cheap throw-away pen.

The series of informative sketches on these pages are used as the basis for many subsequent paintings, and the sunflower was the inspiration for the step-by-step project on pages 34–37.

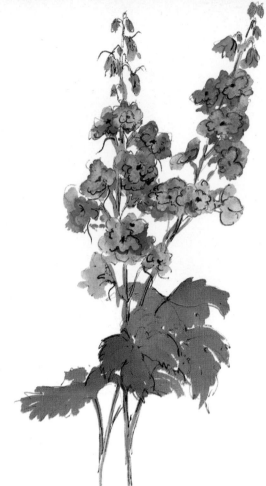

Delphiniums
The small massed flowers and the large serrated leaves are partially sketched in with black waterproof ink. Coloured washes are laid on top and dark blue, light blue and pink washes form the flower heads.

Size: 150 x 280mm (6 x 11in)

Poppies
A variety of coloured inks are used for these poppies; they are painted mainly with the dipper end of the ink bottle and a brush. The wet-into-wet technique gives a fluid look to the picture and the leaves are spiked by my finger nail teasing out the wet ink. Artificial poppies are a good substitute if you have no fresh flowers to work from.

Size: 280 x 280mm (11 x 11in)

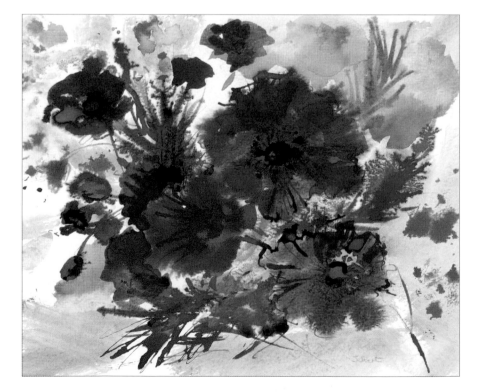

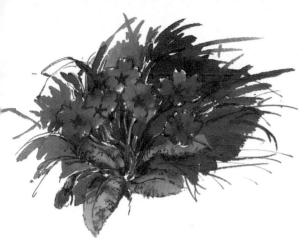

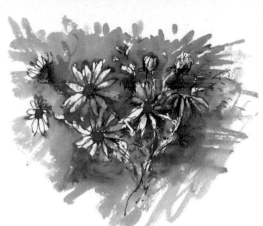

Daisies

The basic outlines of this study are drawn using a felt-tip sepia pen. The daisies are untouched white paper, with washes of non-waterproof brown and green inks for the background.

Size: 125 x 115mm (5 x 4½in)

Primroses and daisies

This attractive cluster of primroses is created using non-waterproof sepia ink, a felt-tip sepia pen and a steel-nibbed pen. The flower heads are laid in with flat washes of yellow paint and a touch of brighter yellow ink. Sepia pen is dotted on to the leaves to create texture and it is also used to add final details.

Size: 170 x 125mm (6½ x 5in)

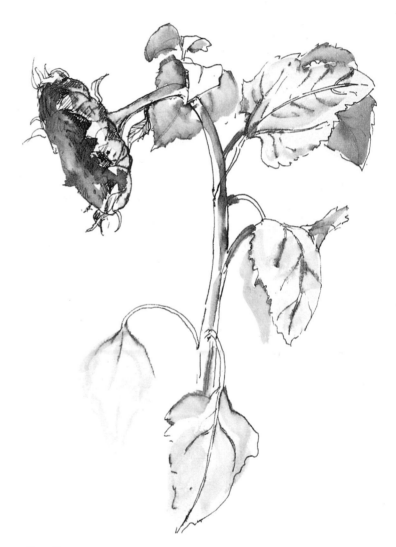

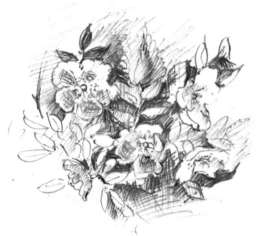

Dogroses

A blue ball-point pen is used for this simple sketch. The tones are intensified by a network of cross-hatching, and the mid-tones with just a light rendering of scored marks. The angle of the branches and stems helps to keep movement within the study.

Size: 90 x 90mm (3½ x 3½in)

Sunflower

This study of a sunflower is taken from my sketchbook – I painted it whilst on holiday in France. The inked drawing is then washed over with clean water and a brush to try to capture the essential shadows, textures and tones.

Sunflowers in Tuscany

On a recent painting holiday with some of my students in Italy, we found this wonderful scene with a typical Italian house set against a field of sunflowers. At the time, I made several sketches, and for this project I decided to use the one below, in which the large flower heads give a feeling of space and structure to the whole scene. I kept the drawing simple and direct, with the deep greens of the background and foreground framing the mass of glorious yellow in between.

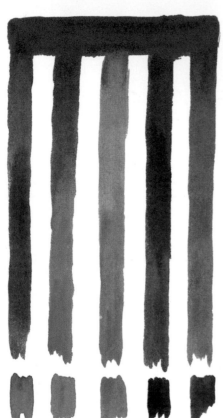

ABOVE
This colour mixing chart shows how to mix a combination of basic watercolour colours with Hooker's green to create a variety of natural greens, some of which I use in this demonstration. From left to right: burnt sienna, Vandyke brown, yellow ochre, ultramarine blue, olive green.

You will need

300g (140lb) watercolour paper
Pencil
Waterproof, steel-nibbed pen
20mm (¾in) flat paintbrush
No. 6 paintbrush
Watercolours: yellow ochre, cadmium yellow, burnt sienna, cerulean blue, olive green, Naples yellow, violet

Original sketch

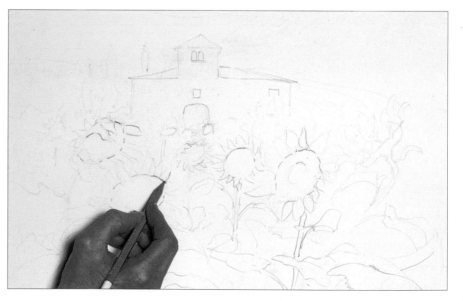

1. Draw in the outlines of the picture using a soft pencil.

34

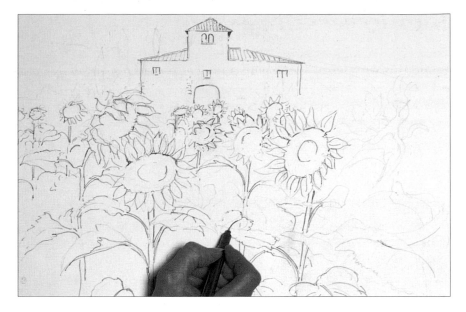

2. Draw in the flowers and the building using waterproof ink in a steel-nibbed pen.

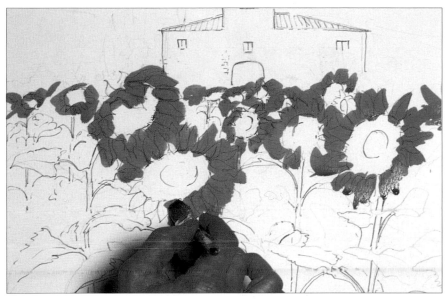

3. Apply a yellow ochre wash over the sunflower petals with a flat brush.

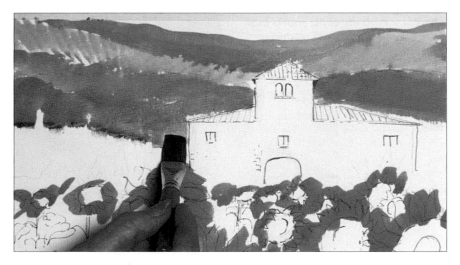

4. Mix burnt sienna and Naples yellow and paint in the distant hills. Paint in the green areas.

5. Paint in the trees and foliage in the middle distance using a mix of cerulean blue, burnt sienna and olive green. Build up the colours, tones and shadows in the middle distance.

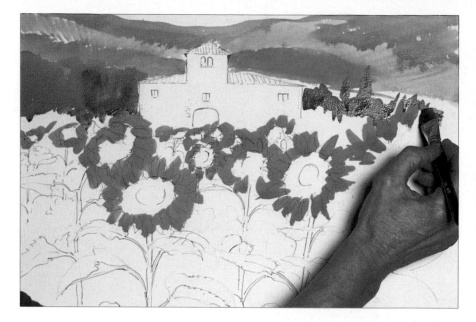

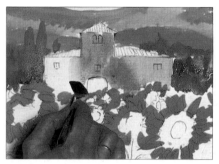

6. The yellow of the sunflowers is reflected in the building. Apply a basic wash of burnt sienna and cerulean blue, then add yellow ochre while the paper is still wet.

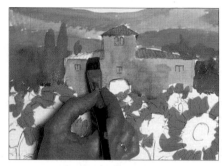

7. Apply burnt sienna to the roof.

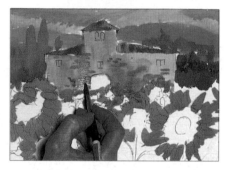

8. Build up the brick work and texture on the front of the building using a No. 6 brush.

9. Use the flat brush to apply light and dark green washes over the foreground area between the flower heads.

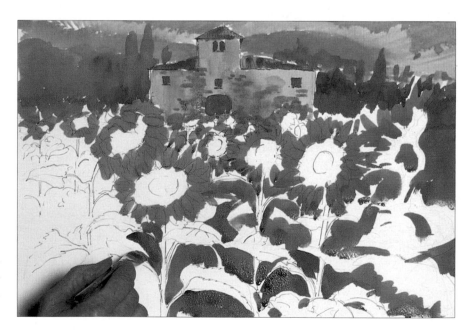

White daisies
This is painted with a
bamboo stick, using
waterproof white ink on blue
pastel paper.
Size: 230 x 150mm (9x 6in)

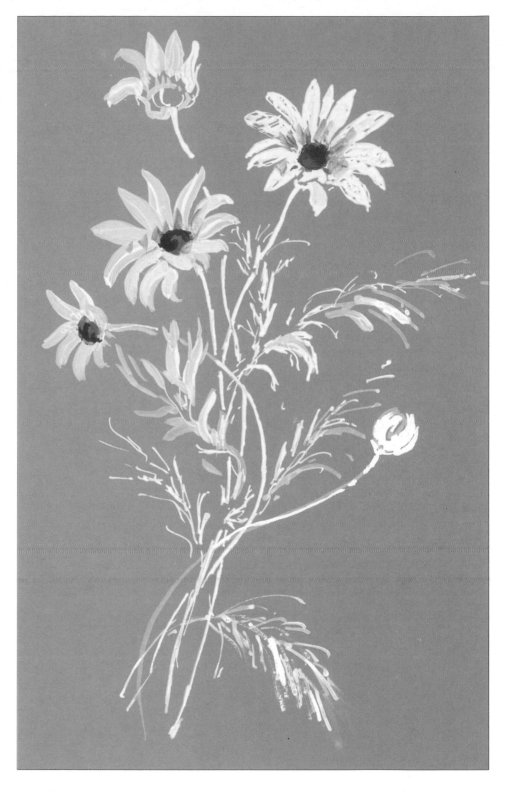

Left
Pansies
Coloured acrylic inks and a ruling or drawing pen are used for some
of the finer details, and the dipper end of the ink top is used for the
thick lines of the stems and the bud. A diluted wash of blue and
yellow ink is painted in to soften the background.
Size: 200 x 350mm (8 x 13¾in)

Buildings

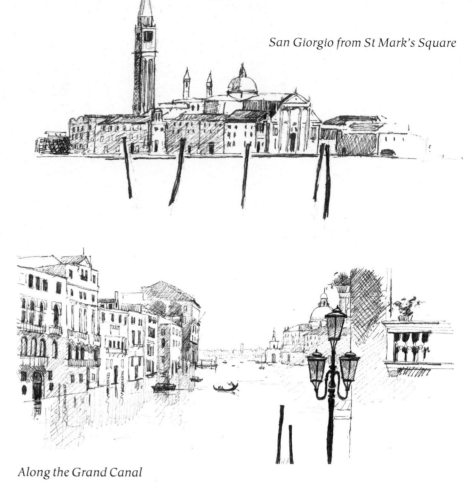

San Giorgio from St Mark's Square

Buildings feature in many different scenes, both in the countryside and the town. Line and wash is suitable for depicting all kinds of buildings, whether modern or traditional. Lines (linear perspective) can create obtrusive, fragmented or delicate effects; and heavy lines can add precision, boldness and energy to your work. Colour washes soften edges, add interest, and offer an illusion of distance (aerial perspective). In the examples shown here, the beauty and versatility of line and wash is made clear as the two techniques fuse.

Before starting to sketch any building, hold a pencil up vertically, and use this to gauge straight lines so that you know exactly what is happening in your picture. In this way, you will discover if your perspective view is correct and you can adjust it as necessary.

Along the Grand Canal

The Punta della Dogano and church of St Maria della Salute

Sketches of Venice
These quick studies, taken from my sketch book, are in waterproof ink, with pencil guidelines underneath – these can be rubbed out when the ink has dried. Carefully observed studies are useful to refer to, and they can be backed up with photographs to aid the memory further.

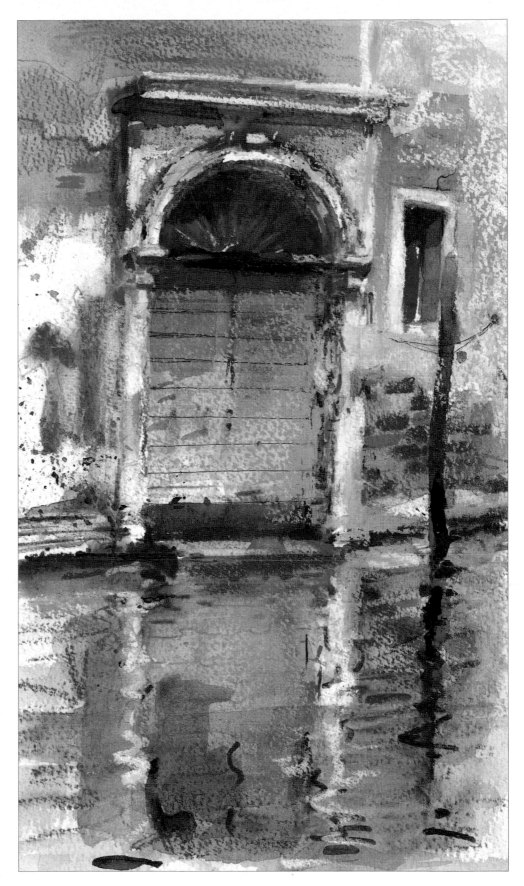

Venetian doorway

A section of a building can make a successful picture. Here, a tight, accurate sketch underlines the work. A steel-nibbed waterproof pen and washes of water-colour are used. The old distressed brickwork is created by combining small areas of dry brushwork with undiluted watercolours used directly from their tubes.

Size: 180 x 280mm
(7 x 11in)

Alms houses

This group of medieval alms houses just took my breath away! It is a beautiful gem of a scene and it can be found in the Essex village of Dedham, England; it is a real magnet for painters. To me it seemed an ideal subject for line and wash. Details of the painting opposite are shown below.

I applied touches of masking fluid and washed in the flowers and foliage with a mixture of wet-into-wet watercolours. When the paint had dried, I rubbed off the masking fluid to create white highlights. The impression of the small brick wall was achieved using an art pen and burnt sienna watercolour.

The tiles needed a rigid structure, but I did not want to overwork the roof. I drew in several of the tiles with a non-waterproof art pen, then painted small areas using burnt sienna, yellow and a touch of olive green. I let the paint dry, then added soft broken lines to indicate more tiles. While the ink was wet, I washed over the lines with clean water to diffuse them slightly.

The windows were cross-hatched with masking fluid, then a dark wash was painted over the area. When the paint was dry, I rubbed off the masking fluid to reveal the leaded panes. A similar effect can be achieved by applying white ink in a ruling or drawing pen over a dark wash. The dramatic shadows on this building give the illusion of depth and structure. They were painted with a wide brush, using a combination of violet, burnt sienna and blue.

The splendid gable was sketched in with an art pen. The timber shapes were filled in using a diluted alizarin crimson wash, which allowed the paint to bleed slightly.

Alms houses, *the finished painting.*
Size: 360 x 305mm (14 x 12in)

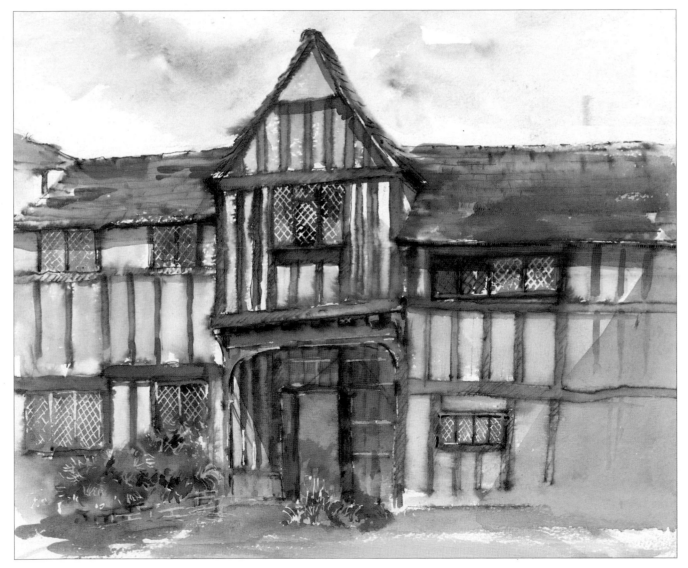

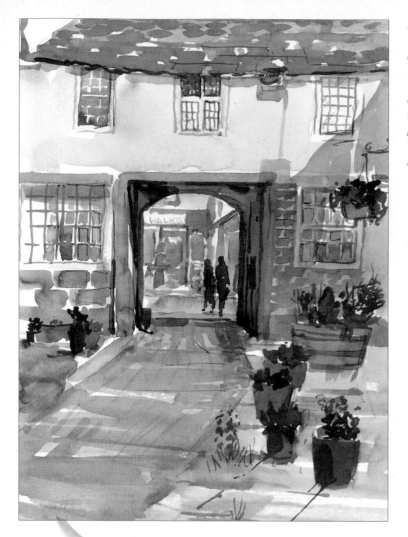

Burford, near Oxford

This study is worked in coloured inks, watered down like watercolours, then applied with a ruling or drawing pen and brush. I was interested in the dramatic peephole effect of the courtyard entrance and added figures to it to make it even more of a feature. Small areas of pen work highlight details on the pots and windows.

Size: 180 x255mm (7 x10in)

Mostar bridge

This painting was worked whilst on holiday in the former Yugoslavia. It is a beautiful fairytale subject, which uses washes with stabs of ink here and there to help tie the subject together. The foreground trees, the tiny figures and the windows are all in mid-toned ink.

Size: 255 x 180mm (10 x 7in)

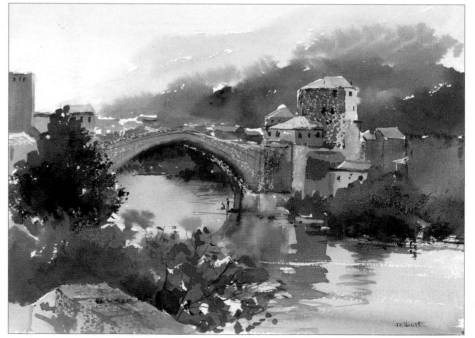

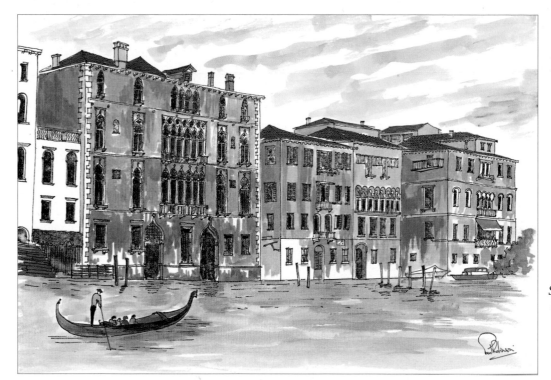

**Casa Bernardo
by Paul Robinson**
*A tight waterproof ink
study in traditional
watercolour washes.*
Size: 410 x 280mm
(16 x 11in)

BELOW
Venetian reflections
*Sepia felt-tip pen and a
ball-point pen are used
to tighten up this loose
watercolour study.*
Size: 380 x 280mm
(15 x 11in)

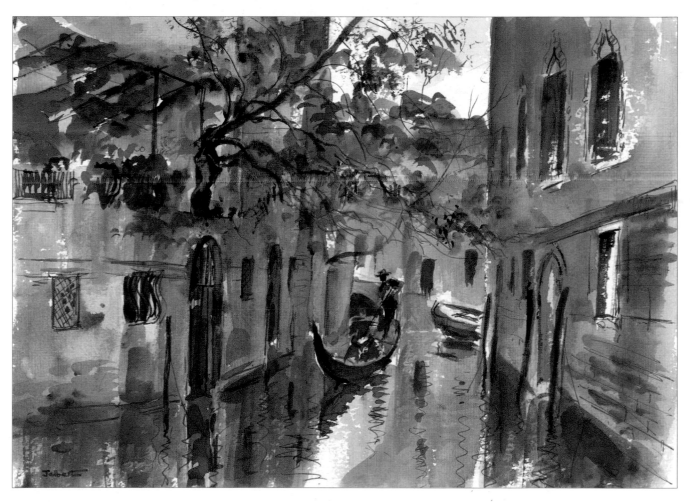

45

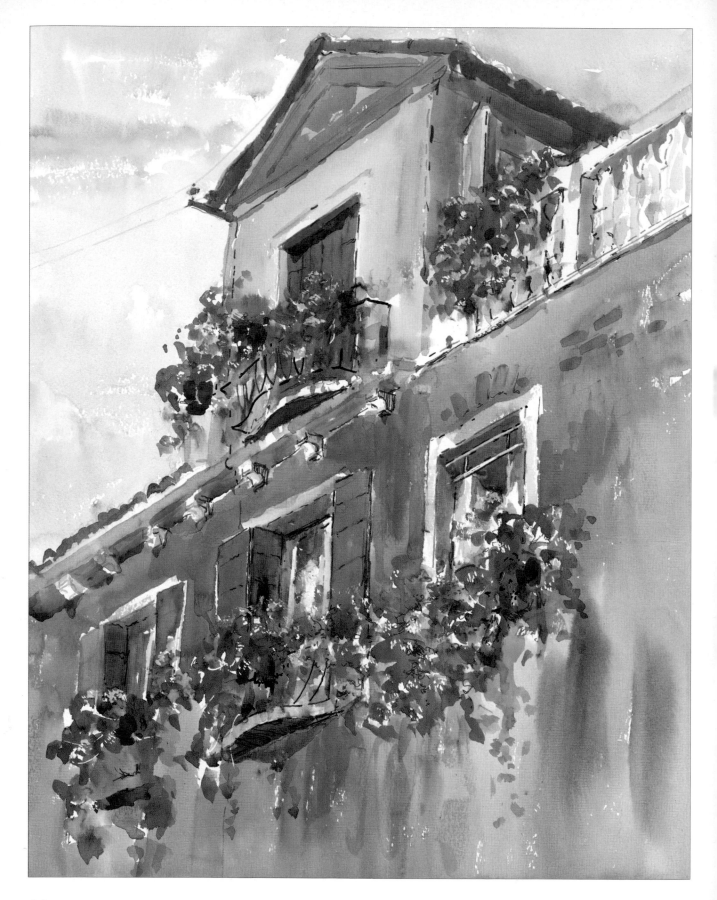

LEFT
Venetian town house

This combination of loose and tight work offers an interesting contrast – the linear outlines of the house are softened by pale washes of colour and by the flowers tumbling down from the balconies.

Size: 380 x 490mm (15 x 19¼in)

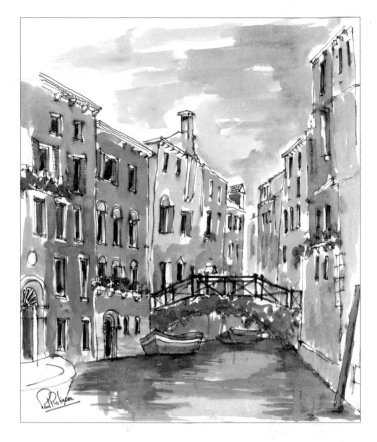

RIGHT
Venetian bridge
by Paul Robinson

This study uses non-waterproof inks.

Size: 280 x 290mm (11 x 11½in)

BELOW
Lisle gites

I sketched this whilst on a painting holiday in France. Watercolour washes are laid in over brown waterproof ink outlines which are drawn with a steel-nibbed pen.

Size: 305 x 200mm (12 x 8in)

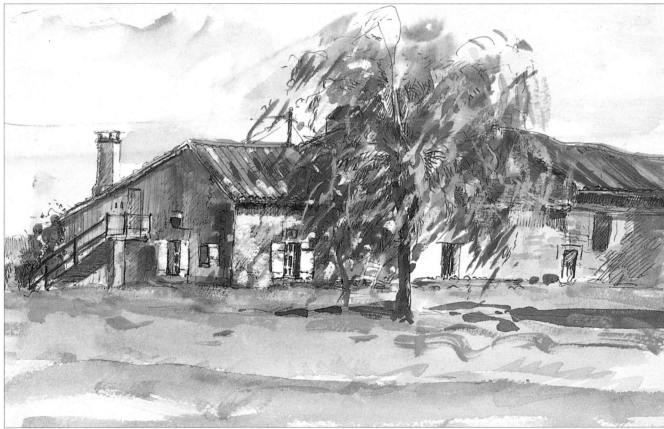

Index